2006

To:
Miss Sandy
♥, A & K³ ☺

P9-CPV-464

Hawaiian *Quilt*
INSPIRATIONS
A JOURNAL OF LIFE

BY PATRICIA LEI MURRAY

Mutual Publishing

First Printing, November 2003
1 2 3 4 5 6 7 8

Design by Sistenda Yim

Mutual Publishing
1215 Center Street, Suite 210
Honolulu, Hawai'i 96816
Telephone (808) 732-1709
Fax (808) 734-4094
e-mail: mutual@mutualpublishing.com
www.mutualpublishing.com

Printed in Korea

Dedicated to
My mother and my grandaunt
Marie Johansen Anderson and Juana Rose Velasquez n Nunez
... for loving me and teaching me to love all that is beautiful.

- ACKNOWLEDGMENTS -

I wish to express my *mahalo*, my gratitude, for every person mentioned in this book, their influence, their quilts, their time, and the significant ways they have inspired my life. My husband, Harry, whose patient listening and kindness has lifted me not only in this project, but constantly in our lives; giving me many reasons to soar. My *ohana*, my family, who I quilt for, and who inspire me to be my best self .

My *aloha* to my contributing photographers: Linda Ching, Fumio Ichikawa, of Japan, and to my friend, Nora Mejide, who worked closely with me photographing with great sensitivity the many nuances I wished to create. To my quilt sisters, here in Hawai'i, and all over the world, and the indescribable bond that we share, especially in the wee hours, while everyone else is asleep. To Reiko Brandon, of the Honolulu Academy of Arts, and Laurie Woodard, of the Hawaiian Quilt Research Project, whose trust and confidence inspired me to tell the quilters' stories.

Most importantly, to *Akua*, to God, for giving me such a wonderful *pū'olo*, or bundle, of talents and fabrics to use and share in my life.

- TABLE OF CONTENTS -

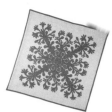

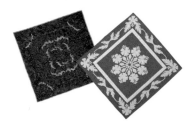

Quilters are rare gems usually found in little clusters. The air sparkles with their laughter, stories and tears. Yards of billowing cloth gather in their laps and at their feet while miles of tiny stitches echo patterns of life. Daily they push through work routines and mothering, and, yes, fathering, hoping to carve out a spot of time for themselves to quilt. And why quilt? Why not just relax...put the feet up, read a good book...do something less tedious?

Quilting is oxygen! It is Valium to some, and honey to others. Inspirations come from everywhere and breathe life into cloth. It is artistic enhancement of cloth, color, design and space. Quilting daily adds up and defines progress, and progress brings satisfaction. It takes a certain kind of being to stay focused on what is sometimes a very large project. It's one thing to have a great idea, but quite another to see it through from birth to precious end, then, after all of that work, to peacefully give it away! Ah, therein lies the mystery of the quilter's heart.

And how do quilt dreams come? When do they come? It's that sacred rush of inspiration pulsing through the heart and mind, confirming that magic is about to happen. Sometimes in the middle of the night you can be found rummaging through fabric stashes, heart beating faster, eyes twinkling or tearing...no one sees...but you know the rush, you feel it. You smile a lot as you discover the perfect fabric pieces for your quilt. A little humming takes place; melody unknown. You choose the path. With a sigh, the dream is born. Your heart is full. Sometimes, you can even get back to bed.

Come with me. Come experience a collection of quilts and the stories from interviews and journals, as well as favorite "words of wisdom" (Hawaiian and English) that mirror life. Discover how these quilts are inspirations of life, and how they eloquently illustrate life. Meet the unique women and men of the quilt world that I know and love. *E Kipa Mai*...Welcome.

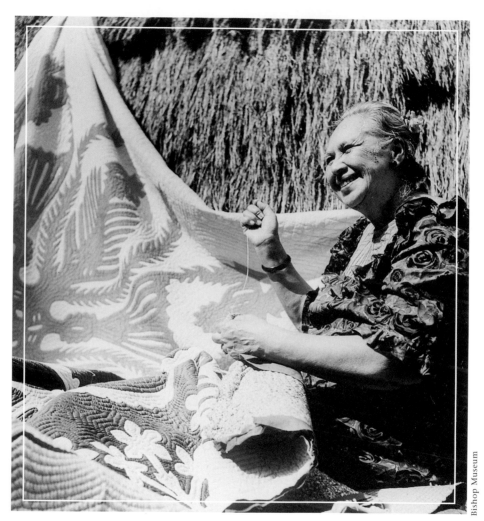

Honored Hawaiian quilter and teacher, Mama Loke Manu.
Ulumau village, 1965

History

THE HAWAIIAN QUILT

With the annexation of the Hawaiian Islands to the United States in 1898, our nation inherited a heightened interest in Hawaiian quilting. Prior to Western cultural contact Hawaiians were proficient in making *tapa*, a paper-like fabric that was used for clothing, bed coverings and burial wrappings. *Tapa* was made by pounding the wet bark of the paper mulberry tree, or *wauke* plant.

Photo of an 'ulu tree

The discovery of the Hawaiian Isles by Captain Cook in 1778, and the subsequent arrival of explorers, traders, whalers and missionaries, provided the islanders opportunities to experience new techniques and designs. However, by the end of the nineteenth century, the making of *tapa* declined and was eventually replaced by the arrival of fabric by the bolt.

The *kapa*, or Hawaiian appliquéd quilt, took the place of the *kapa moe*, the traditionally used *tapa* bed covering. The most striking characteristic of Hawaiian quilts, according to Lee S. Wild, is the cutting of an overall design from a single piece of fabric that is then appliquéd onto a solid-colored fabric. The quilt top is then sandwiched with a backing, a cotton or kapok batting, and then quilted through all thicknesses.

There is a favorite story of how the first Hawaiian quilting pattern came to be. It seems a woman passing by some sheets bleaching in the sun, noticed the shadow of the *'ulu*, or breadfruit, tree's leaves and fruit cast upon it. The shadows inspired her to choose *'ulu* as the first design to quilt.

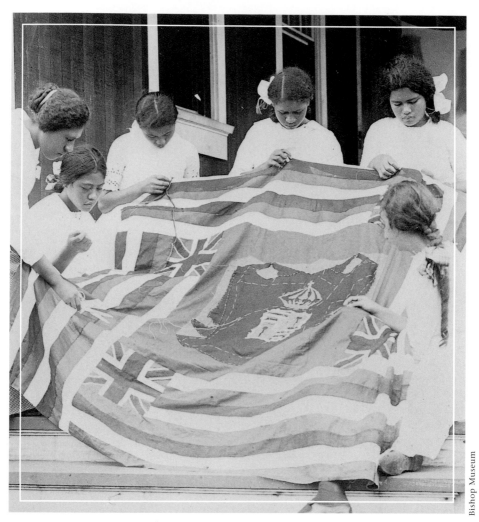

Young women learning to make a Hawaiian Flag Quilt, 1923.

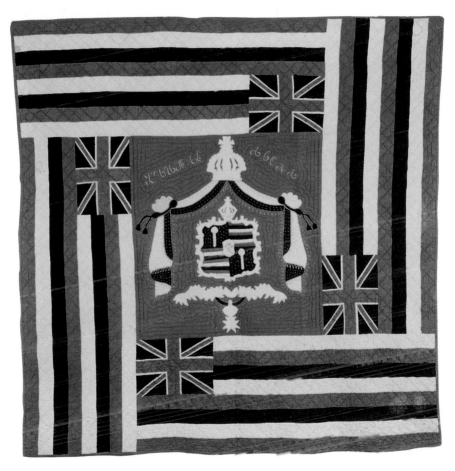

Hawaiian Flag Quilt

THE HAWAIIAN FLAG

For more than 100 years, Hawaiian Flag Quilts have perhaps been the most revered. Typically, a Hawaiian Flag Quilt will display four Hawaiian flags surrounding a royal Hawaiian coat of arms or crown, and will bear the inscription, *Ku'u Hae Aloha* which means My Beloved Flag. Traditionally, the Hawaiian Flag Quilt is a message quilt communicating patriotic loyalty. Although Hawaiian Flag Quilts originated earlier, they took on a heightened significance when Hawai'i's last ruling monarch, Queen Lili'uokalani, was forced to abdicate the throne in 1893. Many of our ancestors stood by, feeling confused and betrayed.

It was the Hawaiian Flag quilters who, in their own way, quietly, yet profoundly, protested the events of this historical tragedy. With love and determination they inscribed into the quilt the motto of the Hawaiian monarchy, *Ua Mau Ke Ea O Ka 'Āina I Ka Pono:* **The life of the land is perpetuated in righteousness.** This motto is our Hawai'i State Motto today.

There are several oral accounts of Hawaiian families hanging their Hawaiian Flags on the under side of the canopies of their beds during and following the annexation of the Hawaiian Islands. This gesture allowed them the assurance that no one could deprive them of their loyalty to their Queen, that their flag was still above their heads, and that it not only granted them rest, but a deep sense of personal pride.

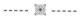

Through the years, Hawaiians have enjoyed quilting the gifts of nature and bringing them into their homes for comfort and beauty. Quilts were given for wedding gifts, birthday celebrations and pure *aloha.* The joy of giving away a quilt, even one that took years to finish, can only be understood by a quilter.

An example of this is found among the early Mormon missionaries who served in the islands. Upon their departure it was not uncommon for the *kūpuna*, or elders, to present them with a quilt or two to express their *aloha*.

Last year, while doing a lecture on Hawaiian quilting on board the *Norwegian Wind*, a member of the audience shared his experience. Former Elder Ronald Stapley was a Mormon missionary who served on Maui. Upon completion of his mission, he received two quilts, one of which was a Hawaiian Flag Quilt. When any quilt, especially a Hawaiian Flag Quilt, is given, there is an unspoken message implied...*you have given me something precious, I want to share what is precious to me*. After the presentation, we reminisced about his missionary years, and the sweet *tūtū*, Margaret Laʻawahine Kawahiki, of Wailuku, Maui, who lovingly made the quilts in 1957.

----- ✴ -----

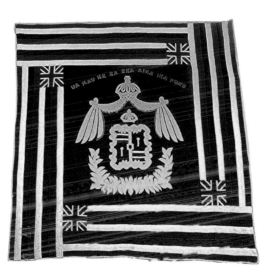

Hawaiian Flag Quilt from Ronald Stapley

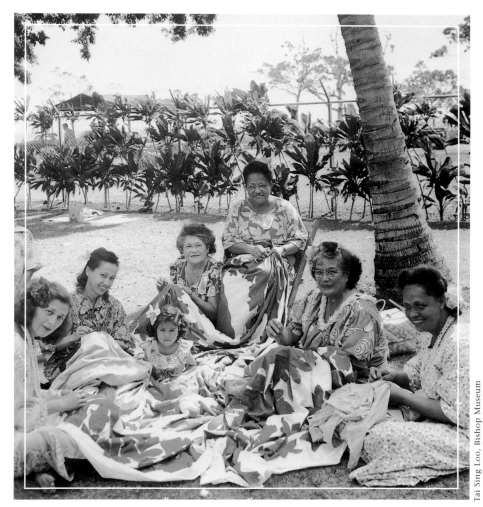

Island women appliquing at Hawaiian Village of the Ala Moana Park,1949.

ʻAʻohe hana nui ka alu ʻia.
No task is too big when done together by all.

THE QUEEN'S QUILT

Another message quilt that makes a compelling statement of the times and events that ensued is the Queen's quilt. May I share my experience with you?

A morning breeze swept silently through the royal palms surrounding 'Iolani Palace. The sun warmed my neck and shoulders as I waited to enter. Arrangements had been made and permission granted to view Queen Lili'uokalani's quilt displayed in the Palace. After the proper registration, I was escorted to the Queen's bedroom on the second floor, her place of imprisonment for 10 months following the overthrow of the Hawaiian government. Upon entering, I found the room dim and the lamp lights low. And there, encased in the center of the room, was the Queen's quilt.

Even with the limited lighting to protect the quilt, I could still see the vibrant colors and delicate hand-embroidered ribbon messages. And as I strained to read the names and messages, I felt the sting of tears in my eyes...especially when reading the Queen's full name, and that of her lady-in-waiting, Eveline Townsend Wilson. I imagined how they might have passed the time together, speaking quietly, selecting threads and quilting this very piece. As a quilter, I marveled at the variety of rich fabric swatches, and pondered perhaps the stories that came with each piece. I smiled at the delicate beauty of the even, embellishing stitches, and precision in cursive embroidery of the names and messages. I touched the quilt with my eyes.

I had come to see and feel the *'uhane*, or spirit, of the quilt, and I will ever be thankful for the moment of this personal visit in my life. I felt moved to give something in return; a *ho'okupu*, or gift. And so I sang for her.

My heart chose the strains of *Ku'u Pua I Paoakalani,* a song she had composed in that very room, and dedicated to John Wilson, the little boy who brought her flowers, wrapped in newspapers, from her garden in Paoakalani. As I sang I closed my eyes and pictured her happiness in receiving the flowers...and my song.

----- ✳ -----

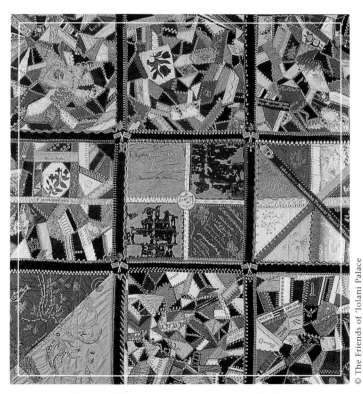

Queen Lili'uokalani's Imprisonment Quilt.

Ku'u Pua I Paoakalani

Written by Queen Lili'uokalani while in prison at 'Iolani Palace, 1895

E ka gentle breeze e waft mai nei
Ho'ohāli'ali'a mai ana ia'u,
E ku'u sweet never fading flower
I bloom i ka uka o Paoakalani.

'Ike mau i ka nani o nā pua
O ka uka o Uluhaimalama
'A'ole na'e ho'i e like
Me ku'u pua i ka la'i o Paoakalani.

My Flower in Paoakalani

O gentle breeze that blows softly here,
Bringing fond memories to me,
O my sweet never fading flower
That blooms inland of Paoakalani.

I always see the beauty of the flowers
From the upland of Uluhaimalama,
But these cannot compare
With my flowers in the serenity of Paoakalani.

- Hui Hānai, Honolulu, Hawai'i, 1999 -

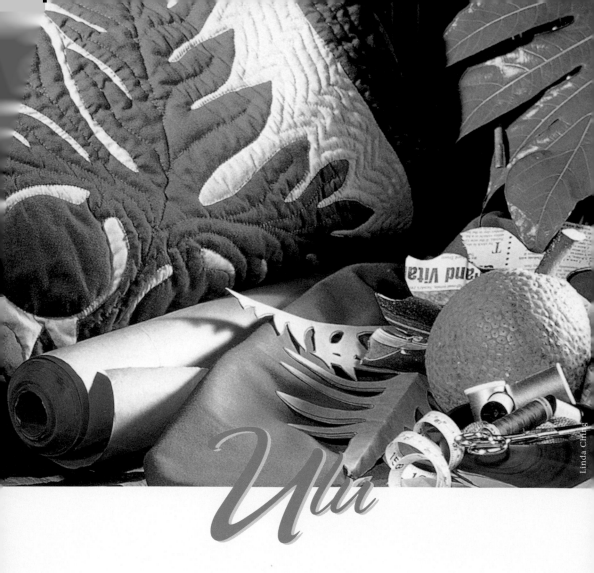

Linda Ching

Ulu

Abundance

MY FIRST QUILT

Just think, in the '80s, Kamehameha Schools provided one of the most exciting continuing education programs. As a participant, I took Hawaiian language, *lau hala* weaving, Hawaiian quilting and, yes, I even made my own *'ukulele*. When I signed up for Hawaiian quilting, I came to know Gussie Bento, my *kumu kuiki*, or quilt teacher. Previously, my quilting experience was limited to blankets for my babies, and other things for our home. But the moment I became acquainted with the spirit of Hawaiian quilting, I knew I had to be there. The impression came gradually as I observed the precision and care required, right from the beginning, in learning this cultural art. "Watch good," I told myself. I discovered that there is a simple yet precise way to cut a pattern, unfold it, center it, and appliqué it to the background. And we haven't started quilting yet! "A good beginning makes a good finished product," something *kūpuna*, or elders, would say.

And the patterns, how beautiful they were—leaves and flowers spread out before us. It was a heavenly chance to quilt the beauty I found in nature, and bring it into my home. And our teacher was so inspiring, expressing faith in all of us as we worked. It was a Hawaiian gesture of peaceful encouragement, guiding us to know that we would benefit from our patience and diligence.

Our first pattern was *'Ulu*, or breadfruit. We learned that it was a good omen to do *'Ulu* first. *'Ulu* translated means prosperity, abundance and increase. In the coming weeks, we came to understand that, as we continued with our work, we actually displayed more abundant thinking and were prompted to continue quilting in our life. Not only did I finish the first block, but I ended up with nine! I decided not to make pillows but put them all together into one quilt. I worked on them during dentist and doctor appointments, soccer games, and Honolulu Boy Choir rehearsals. I love it! My First Quilt was featured in the 2003 Kokusai Art Show in Japan.

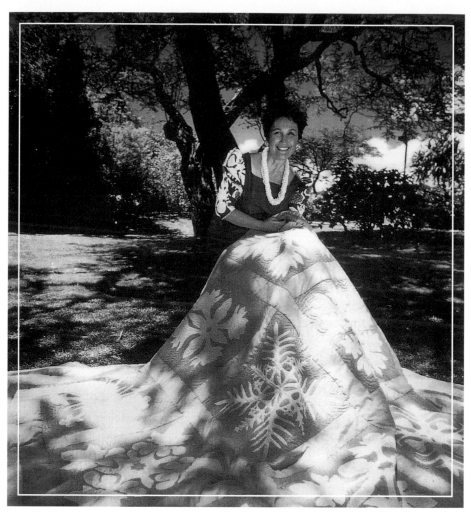

My First Quilt — 1980s.

As a little girl, I always had a fascination with fabrics, laces, threads and buttons. My sisters and I loved to run our fingers through my mother's treasure trove of colorful buttons and hear them clink down into the big red button can. My mother, Marie, was my greatest influence in sewing. She was a talented seamstress with a quiet driven spirit that surprised many as she supplied us with the prettiest dresses for Easter and Christmas, just like the ones in the catalogues and magazines. This is one of my favorite photographs. I am two years old and wearing a lace and organdy pinafore my mother made, an example of her handiwork. Her sewing machine was a reconditioned Singer™ my father rescued from Army surplus after the war.

My father, Harry Anderson, was a welder at Pearl Harbor during the war, a resourceful and creative man who influenced our approach to living. He taught us how to make wonderful things with what little we had, and to enjoy the smarts it took to be original. My parents inspired us to realize the possibilities of being able to create a life filled with *pīkake* dreams while living on a *melia* budget.

----- -----

"The future belongs to those who believe in the beauty of their dreams." —Eleanor Roosevelt

HIBISCUS *(Pua Aloalo)*

Elizabeth Root has not only inspired me as a friend and quilter, but she also has been an inspiration to whole villages. In her travels she has taught women around the world the art of Hawaiian quilting, not only allowing them to find joy in this endeavor, but providing them a way to make a living. Her work is readily recognized and enjoyed in Hawai'i.

This hibiscus quilt is just one of her many beautiful designs; I just adapted the border. I loved the warm tone of cinnamon on cream. It reminded me of hot chocolate on a rainy night. This reverse appliqué was also fun to do. It started with an innovative stamped pattern technique that I snipped into as I appliquéd, making the pattern actually come to life before my eyes.

The hibiscus quilt sailed with me to each of the neighboring islands aboard the *S.S. Independence.* Each year at Aloha Festival time, different cultural artists are invited to share their work on board with the guests. I had the pleasure of teaching quilt workshops, singing and dancing the hula.

Each time I sailed I could take a guest. This time I took my daughter, Amber, who was my *kōkua,* or helper, for the workshops. After our work was done, we would sit out on the deck together, talking and quilting this very piece, till the sun went down...A sweet memory we made together, and shall always treasure. Hibiscus was featured in the 2003 Kokusai Art Show in Japan.

----- ✳ -----

"Happiness is recognizing that what we have is enough.
Joy is knowing that what we yearn for, we've had all along.
Love is understanding that what we cherish we could easily share."
–Patricia Lei Murray

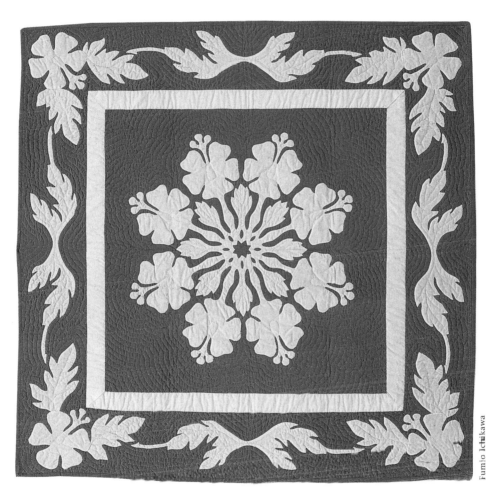

HIBISCUS
Designed by Elizabeth Root Quilted by Patricia Lei Murray.

Fumio Ichikawa

21

When Mary Haunani Cesar was born, she was blessed with the talents of both grandmothers. From her Hawaiian grandma, Edith McKinzie, she learned to hula; and from her *haole* grandma, Beryl Watson, it was painting, crafting and sewing. Her interest in Hawaiian quilting came after returning from Japan where she worked for several years.

She experimented first on her own, with patterns from quilt books, and then decided to take a course from Carol Kamaile in Mānoa. After all the basics were absorbed, she discovered that designing would become a passion.

Although Mary considers herself a traditional Hawaiian quilter, she has developed a great innovative spirit. She has both designed and quilted a rich array of works, each with an island flair that utilizes all the wonderful techniques that are constantly at her disposal as she travels and teaches.

Over the years, Mary, has enjoyed the freedom to be creative and stretch her imagination and skill, gifts from her *kūpuna*. As a result, she has found herself in a place that respects her traditional beginnings and acknowledges the spontaneity of fresh new ideas. She strongly believes that there is room for both disciplines to exist in the Hawaiian Quilt world, and we should welcome each other.

Mary is well known internationally as a teacher and her work is featured in quilt magazines and catalogues. She can be found each year in Houston, where all the quilters gather to teach, learn and buy all the latest implements of the trade. She's always looking for new, easier and faster ways of working and sharing them with us.

This quilt is her personal design, entitled "Hawaiian Fusion"; a stunning showcase of various island flowers. Each petal, leaf and bud is fused by hand onto a hand-painted background and then quilted. It is just one of her quilts chosen to be featured at the 2003 Kokusai Art Show in Japan.

----- �֍ -----

Fumio Ichikawa

HAWAIIAN FUSION
Designed by Mary Cesar. Machine quilted by Kathy Bento.

MONSTERRA AND FERNS

Susan Kinkki and Donna Burns were my inspiration for this Monsterra and Fern Quilt. Susan is an innovative quilter and hand dyer who lives on Kaua'i. I went to visit her home and fell in love with what I call the "Kinkki Greens." I bought a bundle of these fabulous hand-dyed cottons, and stashed them, patiently waiting for the "just right" project to come along.

Donna Burns is a friend, an artist and product designer. We were part of Native Books and Beautiful Things, a store featuring local artisans. As an artist she enjoys uniquely incorporating a whole variety of leaves into her designs, one of which is Monsterra.

Donna's monstera shapes were always very welcoming, and inspired me to include these hardy leaves along with ferns for an island garden effect. But ferns have so many tiny leaf details, I wondered how I would ever keep their crispness alive in the quilt. Then, I discovered silk ferns. I just removed the stiff ribs and carefully laid each fern out and fastened them down.

Remembering my sheer Hawaiian technique, I decided to experiment with tulle instead of organza. The effect was so exciting and encouraging. I laid green tulle over all the delicately cut, hand-dyed monsterra and silk ferns. I basted them down and began to quilt.

My husband and I were planning our vacation that would include train and coach rides through the Canadian Rockies. Every quilter needs some little project to work on, and so I decided to take the monsterra quilt. It wasn't a little project, but it made my heart happy, and my husband was happy, too; he could snooze whenever he wanted. It was such a fun quilt to do, I finished it before we got home. A journey quilt!

----- ✳ -----

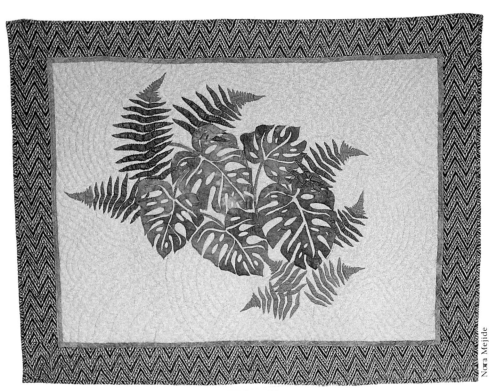

Nora Mejide

MONSTERRA AND FERNS
Designed and hand-quilted by Patricia Lei Murray, 2003.

Linda Ching

Kaunaloa

Endurance

STOLEN LIVES

On September 11, 2001, our breath was taken away by the devastation and tragedy foisted upon New York City and our country. Everywhere people struggled to find words to express their grief. Quilters all over the country picked up their simple tools of needle, thread and fabric and quilted images and messages of empathy and hope.

The Annual International Quilt Festival in Houston was already scheduled just 6 weeks away. An announcement rippled through the airwaves stating that a special exhibit of September 11th quilts would indeed be included in the festival. Expectations were that perhaps fifty quilts would arrive, but by opening day, close to three hundred quilts were received. And, so, they created a wall of fabric images right down the center of the great hall, where thousands paused, reflected and silently shed tears of disbelief.

All the quilts that arrived were featured in a book entitled *America from the Heart,* by Karey Bresenhan, making it possible for the rest of the world to witness this great outpouring. In a quiet moment of leafing through this book, my heart stopped as my eyes fell upon the quilt, entitled "Stolen Lives," by Maria Elkins of Dayton, Ohio. I carried that image around in my mind consciously for quite a while, and then one day, I simply decided to reach out into the great universe and find her. I was so thrilled to hear her answer the phone...we talked and have become friends as well as quilt sisters. She has graciously given me permission to share her work with you.

----- �֎ -----

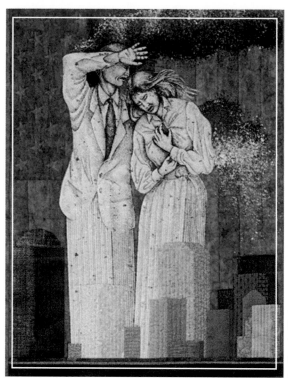

STOLEN LIVES
By Maria Elkins of Dayton, Ohio.

Awful feelings swept over me: Dismay, disbelief, revulsion, shock, grief. I kept thinking about all the people in those buildings and on those airplanes. How could anyone do that to another human being? The image of the towers as two people filled my mind and wouldn't leave; symbols of the lives that were callously snatched away, leaving behind families with gaping holes.
–Maria Elkins

Why do I watch?

Why do I watch continually as I try to work here in my home?
Why, when I lay down to rest, do I still watch and listen, gradually lulled to
sleep by the reporting voices? And when I waken, only to resume?

I watch because by doing so, I feel I am there taking some of the pain,
lifting some of the sorrow, lifting with my eyes and heart the steel beams,
helping, looking for something good, hoping to hear of someone found alive.

I light candles in my home, I sing the songs of comfort, I listen to the stories
of the families who received cell phone calls before disaster struck.
I ache as I hear them, imagining their disbelief. I say a prayer,
many prayers, for them, for the firemen, policemen and volunteers,
the President of our country, and the reporters present for so many hours.

As I watch I quilt, stitching a rhythm that quiets my soul and hoping
by my stitching, I could sew everything back together again...taking away
the deepest sorrow that we all share.

Hawai'i is so many miles away, but in my heart I reach out
and embrace the sadness of many broken families and send love.
I look into the heavens and know that our future is truly in the hands of God.
May we find peace.

- Patricia Lei Murray -
September 12, 2001

TI GARDEN

One of the most important plants in a Hawaiian garden is *tī*, or *kī*. The colorful leaves can be used for clothing, thatching, wrapping foods, decorations, ceremonies and healing. Kūpuna use chilled leaves in relieving fever, and the pounded root juice is used as medicine.

Tī plants come in a wide variety of colors, from shades of green, reds, stripes and even black. Tī can be found in almost every yard and on every island.

I designed this quilt during my recuperation from a broken leg. It was important for me to surround myself with as much positive energy as possible, and the thought of creating my own healing garden as I quilted was a powerful gift to myself.

It was also at this time that I was called to audition for *You Somebody* which was to play at Diamond Head Theater. "I'm on crutches," I said. "Fine," says Donald Yap, musical director. "Bring them with you and we'll do, *"I Could Have Danced All Night,"* it'll be great!

This was in May, the play was in July. Guess what? It was great! I somehow managed it all. The whole experience was so rejuvenating and healing...good people, good music, and, yes, my quilting. When I was not needed on stage, I was in the *tī* garden, quilting.

----- ✳ -----

"Nothing is impossible to a willing heart."–John Heywood

*"The greatest pleasure in life is doing
what people say you can not do."*–Folk wisdom

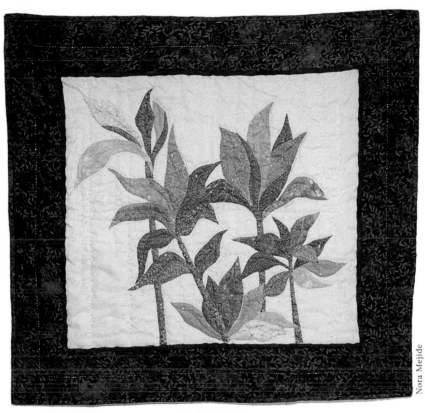

Nora Mejide

TI GARDEN
Designed and hand-quilted by Patricia Lei Murray, 2002

Would that all the world were quilters,
We would bind our wounds, mend our differences,
Harmonize our colors, and blend our borders...
—EQ Digest

31

MY JAPANESE GARDEN

My mother's love for fabric inspired me to begin my own collection. I loved Japanese fabrics and over a period of about 20 years I realized I had quite an accumulation. I also love quilt books, and while browsing one day I came upon a simple pattern that I thought would be a perfect showcase for these precious saved pieces. For weeks I worked late into the night making 56 blocks of an adaptation of the "Wheels of Whimsy" design by Wendy Hager and Shirlene Fennema.

Then I broke my leg. A few weeks later our quilt guild was having a retreat out at the ocean in Wai'anae. My friends Sara and Susan insisted that I come, cast and all. The change of venue and pace would do me good. So off I went, taking my blocks and sashing so I could piece them together. What fun it was, and so productive! And being surrounded by my quilt sisters made it so memorable...good food, laughter, tears and the ocean!

Once the quilt top was finished I set it aside and eventually got to the border and back, making sure it was just as wonderful as the front. And then when the holidays were over and my life settled down, I took comfort in hand quilting the entire piece. Why hand quilt? Just so I could once more visit each of my Japanese garden windows, and think of all the good things that were truly imbedded in this quilt.

----- ✖ -----

"Don't wait for your ship to come in—Swim out to it!"

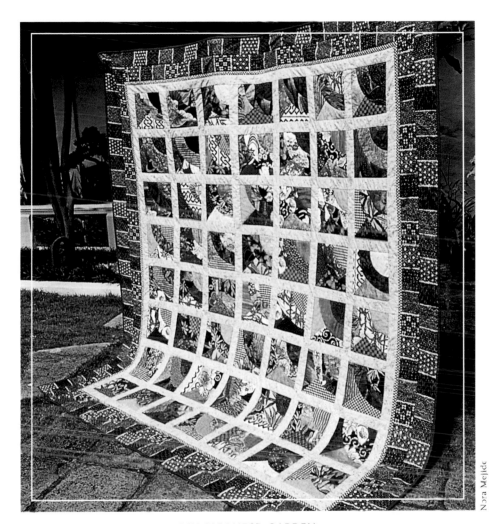

MY JAPANESE GARDEN
Designed and hand-quilted by Patricia Lei Murray, 2003.

KA UA LILILEHUA O PALOLO
(The gentle Lililehua rain of Pālolo)

Before Gussie Lihuʻenuiahanakalani Rankin Bento was born, this quilt had already been started for her by Granny Malia Kealoha Rankin. Five years after the quilt was completed, Granny's eyesight suffered and all quilting stopped. Granny lived with them, and always spoke Hawaiian. They answered in English. She was also known for her *lau hala* weaving, featherwork and lei making—all the cultural crafts that Gussie finds herself enjoying today. She enjoyed displaying Granny's quilts and handwork for her family so they would learn to appreciate her Hawaiian influence on their lives.

From the time she was nine years old, Gussie sat with her mother doing handwork, and soon after found herself drafting patterns in a nearby sewing school. Knitting and crocheting also seemed to come to her very easily, and she was surprised when people marveled at her abilities. "I can do this," she said, "but I can't sing! I'd love to be able to sing."

Gussie is also a self-taught quilter who, while raising her family, always had some kind of project to work on, especially in the late hours while everyone was asleep. This was her quiet time to unwind and soothe her soul.

Her work has been celebrated and hung at our Hawaiʻi State Capital, New York, and in Japan at the 2003 Kokusai Art Show. She has quilted at least six full size quilts, and about 150 smaller pieces, working best when her mind is clear. When times were difficult she simply had to put her work away, because the stitches just wouldn't come, the evenness wouldn't come.

Now, all is well, life has moved on, and she finds herself with more time to be actively involved in teaching again. Gussie was my first quilt teacher and I am thrilled to be once more learning at her side.

----- ✄ -----

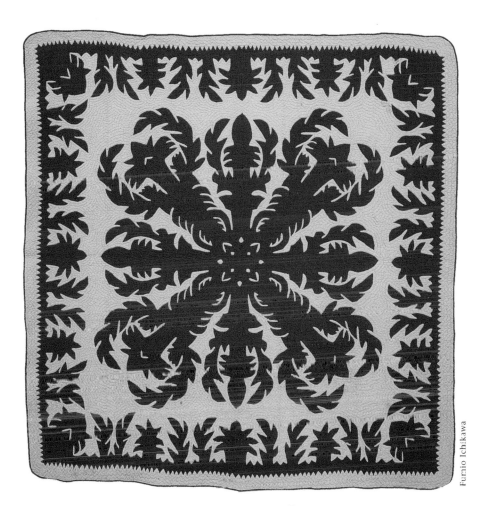

KA UA LILILEHUA O PĀLOLO
Appliquéd and hand-quilted by Granny Malia Kealoha Rankin, 1934.

Fumio Ichikawa

ANGEL'S TRUMPET

My sister, Leo, and I traveled to Waimea, on the Big Island, to visit our mother and take her to the big quilt show. The cherry blossoms were all in bloom despite the winds and misty rain. The whole community was in a buzz because the quilters were beginning to arrive. The Hawaiian Homes Conference Center was the chosen site.

Upon arriving I could see through the windows the big, bed-size quilts; colors deep and bold, hanging like family banners. Hawaiian music playing, seniors singing. Crowds of people, browsing, and swooning over the quilts. Some were wearing *lau hala* hats and feather lei, others wearing fresh *wili* lei, all happily moving about, lilting to the music, greeting each other, hugging and laughing. It was the place to be.

There were little clutches of beginning quilters trying their hand at new projects. Men and women gathered to just sit and quilt. Tables along the back of the room sported quilted items for sale and the far quiet corner was reserved for copying quilt patterns; a service for a small fee.

In all the bustling activity, Leo and I were drawn to the pattern corner and began selecting a few that we were interested in. I had been planning a quilt for Leo and was looking for inspiration. One of the patterns I chose was a simple but elegant design by Kate Penderend, entitled "Angel's Trumpet."

I imagined a table quilt for Leo's new dining room. The recent passing of her husband and the idea of surrounding angels bringing her family comfort and peace was a fitting tribute and my inspiration for this quilt. I was delighted to find all the fabrics I needed for the quilt at home, sitting in my stash, just waiting to be pulled out and used for the Angel's Trumpet.

----- �֍ -----

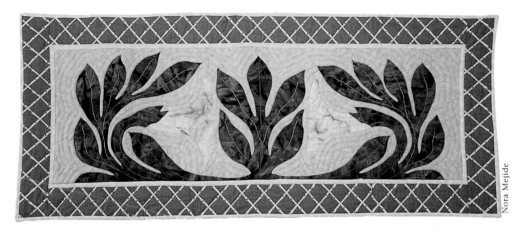

Nora Mejiide

ANGEL'S TRUMPET
Designed by Kate Penderend. Hand-quilted by Patricia Lei Murray, 2003.
For Leo Anderson Akana, Umi and Koa.

PŌHAI KE ALOHA
(Circle of Love)

It was morning. Long shafts of sunlight sliced through the misty forest rain. We were all at Brother Laka's home in Volcano to celebrate Mommy's 80th birthday. My sisters and I had long awaited this weekend, when suddenly tragedy struck. Tippy, my mother's pet poodle and dear companion for many years, accidently died. All of our happiness turned to a deep, piercing *'eha*. How we ached for our mother as each of us, four grown daughters, encircled her in prayer to bear her up; forming a *pōhai ke aloha*.

The day took on an immediate and purposeful direction as each of us set out to assist in a proper burial for Tippy. Mom decided to accept Laka's offer to bury him there on his property among the *hāpu'u* ferns and *'ōhi'a lehua*. We all knew intuitively what our assignments were and without a word, Kanani took a basket and went out to gather flowers and ferns to *wili* a special lei.

Leo and Rosanne planned a burial service and chose music. It was decided that I would make a quilt for Tippy.

We each offered a piece of our clothing for the *kapa*, or blanket. Rosanne offered her white shawl; Leo, her favorite Tahitian T-shirt; Kanani, the hem of her shirt that I braided; Laka, a patch of red fleece; Mom, her scarf worn daily while on their walks, and I, the sleeves of my flannel night shirt. It was amazing how the quilt lovingly took shape; a humble collage of *aloha*.

During the service we reached back into our Hawaiian heritage singing the songs of comfort, and offering solace to our mother. Singing was healing. It awakened us to our gifts and our strengths. It unified us.

As we walked over to the burial place, it rained. All you could hear were the raindrops on our umbrellas and the birds singing high in the *'ōhi'a lehua* trees, reminding us, what the Lord giveth, the Lord taketh away, in His own time and His own way. How compassionate was His love, to put us all together on that appointed day, so that we could truly "be there" for our mother, and for each other...and to feel the grace of His comforting hand.

PŌHAI KE ALOHA
Quilt for Tippy, 2000.

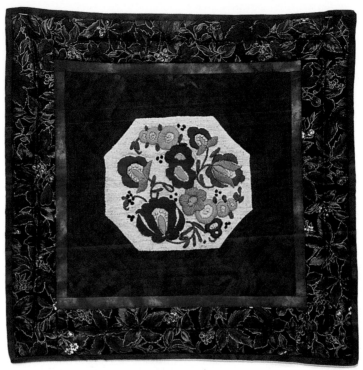

Nora Mejide

WORTH SAVING
Quilted by Patricia Lei Murray, 1997.

This little red quilt was made for my mother for a special birthday. While hunting through my linens one day I found a bureau scarf that my mother had embroidered when she as quite young. Just one side of the scarf was finished. The colorful stitchery was exquisite and needed to be enjoyed instead of hidden in a linen closet. So, I saved the portion that I loved, bordered and quilted it. When I presented it to her she recognized it immediately, and felt so honored that I'd saved it, and not just thrown it away.

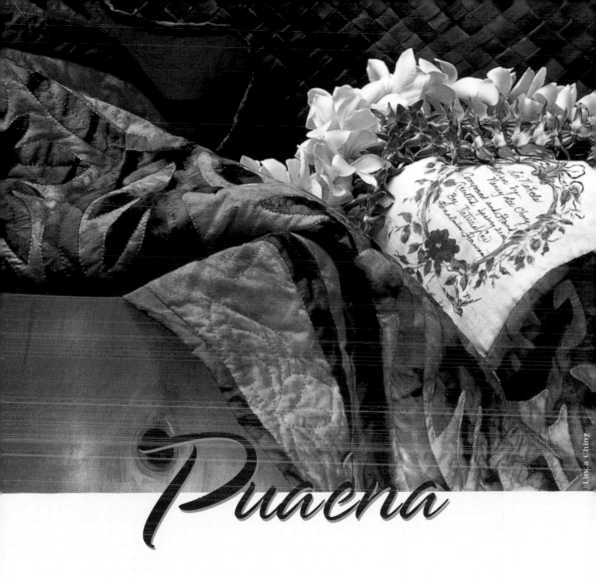

Puaena

Passion

HAWAIIAN AFRICAN TULIPS

My mother loves African tulips and it was her love of them that inspired me to capture their rich glow in a quilt. Each spring they burst through the mountain greens in a profusion of gold. Because the blossoms grow high, I would drive by the trees in *Nu'uanu*, pull over and pick up the fallen flowers, take them home to my kitchen table where I'd study their petal shape and coloration.

My first attempt at a design was not pleasing because it looked too flat and empty for a flower that grew in clusters. I needed a "good think." So, that night, I rested on the idea, and by the next day, the design solution evolved.

The bold fabrics were already a part of my great "stash" and I found myself going right to them. That moment of truth when you realize that you have what you need is pure joy. But I was stopped cold when I realized that I didn't have enough green for the border. The hunt was on. I took a swatch with me wherever I went. I was not confident, however, because the original green was bought some time ago on Kaua'i at Kapaia Stitchery. Later that week, I walked into Kaimuki Dry Goods, and there it was, *smiling* at me. A happy ending to a dream quilt.

Hawaiian African Tulips was one of the quilts chosen for the 2003 Kokusai Art Show in Japan.

----- ✺ -----

"Ideas are funny little things, They won't work unless you do."

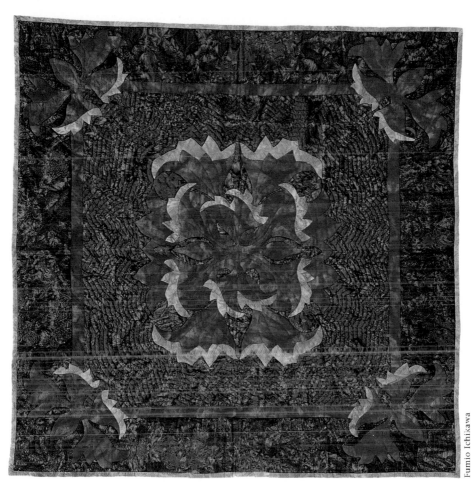

HAWAIIAN AFRICAN TULIPS
Designed and hand-quilted by Patricia Lei Murray, 2000.

AUTUMN ON MY MIND

When autumn comes to Hawai'i, it's the winds that change; no glorious leaf dancing like the rest of the world. Colorful autumn leaves have always inspired me to consider the courage needed to accept change in my own life.

So, on a blustery afternoon, the mental paint brushes came out, and another dream quilt was born. I remember saving a notepad that was the shape of a large maple leaf. What a perfect template, I thought.

Going through my "bold color" stash, I gravitated to Bali and hand-dyed fabrics. Never having seen the *changing of the colors* I felt a freedom to simply use my imagination, so I designed a few different leaf shapes, played with color and even threw in a nice blue leaf. It was fun.

But the real work came with the quilting. Rather than doing contour quilting which is traditional for me, I decided to quilt the wind swirling through the leaves. I chose new holographic and variegated threads, and pulled them through using long and short stitches. The effect was moving and awesome!

This is one of my favorite quilts because it took me outside of the box. I gave myself permission to experiment not only with color splashes, but with style and technique. The outcome was very satisfying.

----- ✖ -----

"When you cease to dream you cease to live."

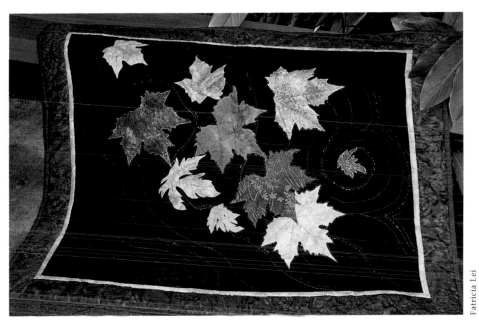

Patricia Lei

AUTUMN ON MY MIND
Designed and hand-quilted by Patricia Lei Murray, 1997.

CATHEDRAL WINDOWS

Windows speak to me. I think it's the thought that there is mystery and magic through windows that are waiting to be discovered, whether real or imagined. I saw this quilt pictured in a quilt magazine, displayed on a farmer's garden fence. Each of the tiny openings was filled with fabric swatches, inspiring me to consider my collection of "can't-throw-this-away" stuff.

This quilt taught me several lessons. My experience reminded me of *lau hala* weaving, where preparation is key. No matter how fun the weaving is, the materials must be prepared properly before actually weaving.

In this quilt, proper preparation for the windows was essential to the fun part of filling in the little openings. Muslin squares were first cut, then each square ironed and carefully folded to reveal the opening ready to be filled. Preparation was labor intensive, but hand sewing the delicious little fabrics into the windows was pure pleasure.

The quilt has no batting. The weight of the folded muslin windows, and the inserts stitched in place, make up the quilt. Squares are continually added, row by row, allowing you to make it as wide and long as you want.

You can truthfully say, after all the folding, pressing and hand stitching, that you have touched each and every inch of this quilt. It reminds me of the Grandmother's Flower Garden quilt.

Some Cathedral Window quilts are now being done by machine. I loved doing it by hand. Yes, it took longer, but that's how the early quilters did it, and I wanted to do the same.

----- �֎ -----

"Every job is a self-portrait of the person who did it.
Autograph your work with excellence."

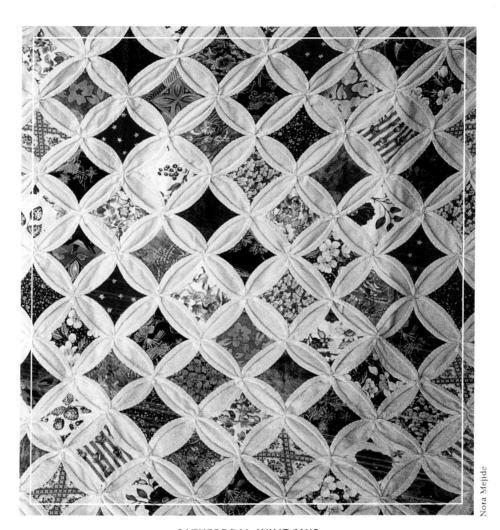

Nora Mejide

CATHERDRAL WINDOWS
Designed and hand-quilted by Patricia Lei Murray, 1999.

Linda Ching

Huapala

Romance

"I'd rather be quilting at a beach house."

Patricia Lei

To me there is nothing more romantic and luxurious than spending time at a beach house. Harry and I often make time to stroll on the shore at sunset, holding hands and watching the kids run out in front with the dog. This is the ocean I love. I am acquainted with all her many moods. She fills me with awe and wonder, and soothes and softens my rough edges. And it is this ocean that inspires me to do my best quilting.

49

THAT'S SHOW BIZ!

Over a period of 40 years, Ron E. Bright has brought audiences to their feet in applause for stellar performances by youth in drama and community theater. He came from humble beginnings from Castle High School drama, to grand expositions showcasing public school children who simply yearned to sing and dance.

Ron Bright has made it possible for so many to excel in theater productions not only in Hawai'i but aslo in theater nationally. To this day he has students who are still on Broadway in New York and in traveling companies throughout the country.

To celebrate this great contribution to our island communities this quilt was made as a surprise for him, Christmas of 2001. His wife, Mo, came to me with a bag of T-shirts that had been saved over the years from all the shows he had done. She asked if perhaps they could be used in a special quilt for him.

Ron and I have been friends for years. I've been in some of his plays like *The Wiz*, and *Carousel*, and he has been my accompanist for performances throughout Hawai'i. So the prospect of creating this special quilt for him as a surprise was eagerly welcomed. It gave me a chance to honor him and to design into the quilt his devoted patriotism and his embracing love for his family. This quilt created memories not only for him but for me as well.

----- ✕ -----

"Love is never afraid of giving too much.
In seeking happiness for others, you find it for yourself."

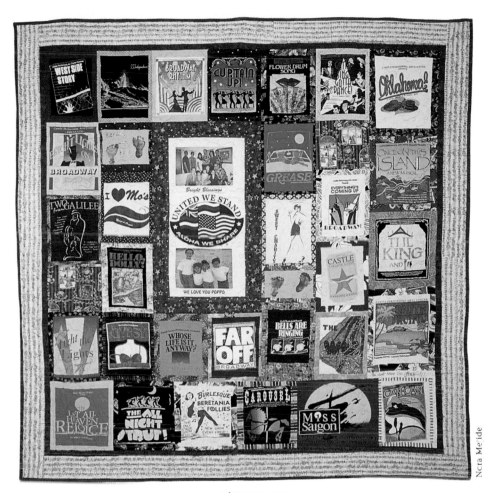

Ncra Meide

THAT'SHOW BIZ
Designed and pieced by Patricia Lei Murray.
Machine quilted by Aime Kusak, 2001.

51

LEI NAHELE

The first time I laid eyes on this quilt pattern by Nancy Lee Chong of the Pacific Rim Quilt Co., I knew I had to quilt it. *Lei Nahele* is its name. I love ferns and especially enjoyed the circular pattern that pulled me into the forest.

The green Bali fabric for the ferns was found at Kapaia Stitchery, on Kaua'i, long before I knew what would inspire me. The gold was from my own Hoffman Bali stash. I loved the flow of the pattern and the intensity of the colors as I quilted, and even imagined giving it an additional name, "Through the Leaves at Sunset."

The night I cut and laid out the fern fabric over the golden background and actually saw the quilt bloom before my eyes was very emotional for me. It was as though, with each leaf placement, my fingers were painting. With great *aloha* my thoughts went out across the sea to designer, Nancy Lee Chong, thanking her for the moment we were sharing.

Lei Nahele was quilted first on O'ahu, then in New York City, and then in No'eau Penner's mountain cottage in the Tall Tree country of Piercy, California...in front of the fireplace, no less. The finishing touches were made here in Hawai'i, at a beachhouse on the North Shore.

Featured in many publications, Lei *Nahele* was also part of the 2003 Kokusai Art Show in Japan.

----- ✳ -----

"*The material is immaterial, let's see what you do with it.*"
—*Masaharu Miyaguchi,* koa *craftsman and dear friend.*

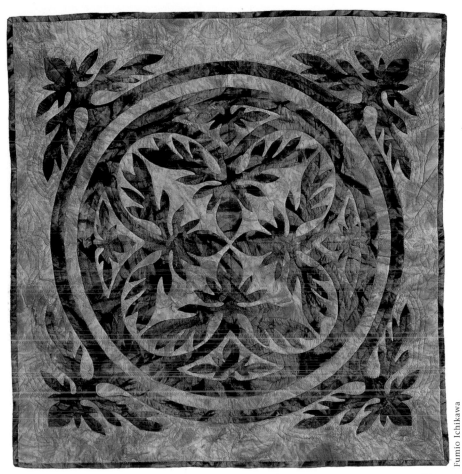

Fumio Ichikawa

LEI NAHELE
Designed by Nancy Lee Chong.
Hand-quilted by Patricia Lei Murray, 1998.

SHEER HAWAIIAN MAGIC

Dawn Caselli, from Kona, was the inspiration for my Sheer Hawaiian Magic Quilts. I took an exciting class from her at Quilt Hawai'i a few years ago, and I've been hooked ever since. The idea was to take basic Hawaiian quilt patterns, cover them with cotton voile and begin quilting right away. I so loved the process that I experimented with many fabrics, especially organza and tulle, and topped them off with an array of metallic and holographic threads for quilting.

This quilt features a simple leaf pattern which could be *Laua'e or 'ulu.* The fabrics used are sheer organza and a Bali watercolor I got from Kapaia Stitchery on Kaua'i. The quilting thread is a silver holographic thread by Madeira that I love using when doing a sheer quilt.

I've enjoyed teaching this technique and have especially been impressed with the many beautiful quilts produced by my students. Their own imaginations have inspired them to step outside of their quilt hoops, take a chance and create something beautiful and satisfying.

Sheer Hawaiian Magic was featured in the 2003 Kokusai Art Show in Japan.

----- ✳ -----

"The difference between ordinary and extraordinary is that little extra."

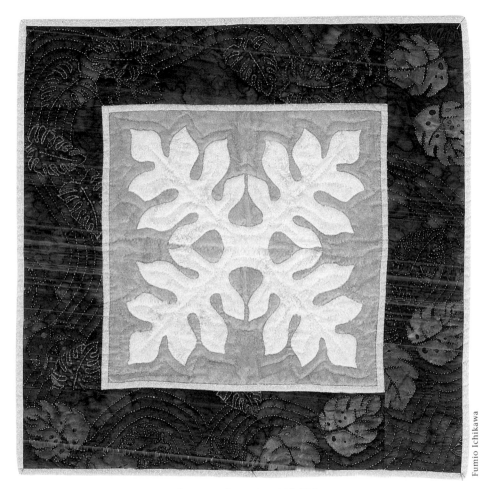

SHEER HAWAIIAN MAGIC
Designed and hand-quilted by Patricia Lei Murray, 2000.

RICE BOWLES AND THE MOON PRINCESS

Elaine Bowles is an innovative quilter and teacher who enjoys being a student. Learning and discovery offer her new freedoms, and allow her to experiment with everything from color and texture to dimension and design. She is a nurse who specializes in case management of high risk pregnancies, so coming home to quilting is her luxury and relaxation.

A few years ago she wanted to design a quilt as a tribute to their family name. She says that there was a lot of male energy in the house; a husband, three sons, and a new grandson. Images of bowls kept coming, the idea appealing, especially since she is a collector of bowls and boxes. Whatever it was, she was determined, however, to assert her feminine energy. The outcome was this wonderful quilt of rice bowls in a cupboard. The design is an adaptation of a quilt by Kaffe Fassett. And glowing amidst the blue bowls is one gold bowl; Elaine's bowl, the queen of the roost.

Another favorite of mine is the Moon Princess. Elaine is also a collector of kimono fabrics and this quilt was originally going to be a kimono showing the various textures of her rich fabrics. As she worked, the quilt evolved into something completely different. A woman's face emerged as well as the moon. She was looking into a mirror, considering the different phases of the moon, perhaps reflecting on the cycles of life. The background fabric featured Elaine's hand-stenciled bamboo, so she decided that the quilt might be named Bamboo Moon.

While searching the internet, she was intrigued to find a story about a Moon Princess who came down to earth, from the moon, in a tiny bamboo shoot. A farmer found her and took her home to his wife. The little princess developed into a beautiful woman who blessed the farmers' lives. It was while looking into a mirror that she saw the moon and realized that the moon was her home. The inspiration to let the quilt become what it was meant to be was a personal moment of truth for Elaine. It encouraged her to trust her senses and listen to her heart. Elaine won first prize that year for her Moon Princess Quilt. The theme was Reflections.

----- ✳ -----

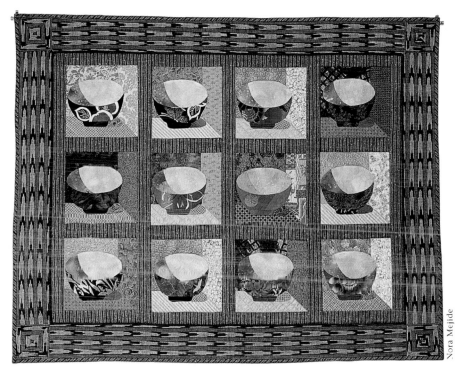

Nora Mejide

RICE BOWLES
Designed and quilted by Elaine Bowles, 2002.

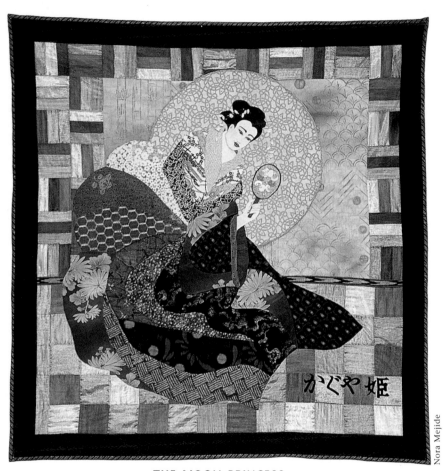

かぐや姫

THE MOON PRINCESS
Designed and quilted by Elaine Bowles, 2002.

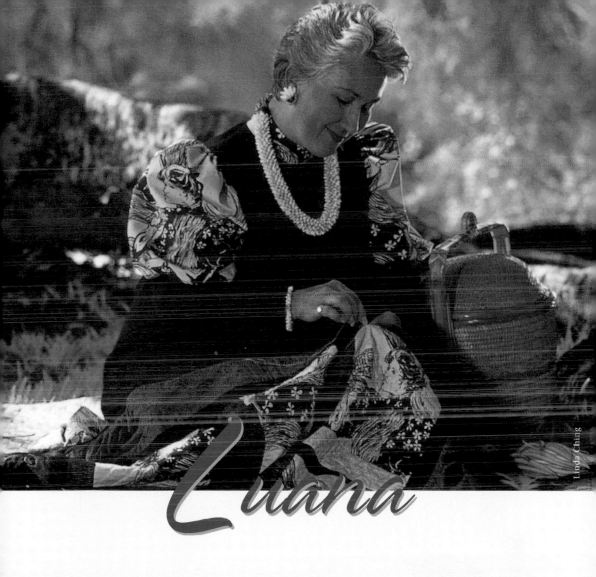

Luana

Contentment

QUILTS FOR THE HOME

Sarah and Richard Kaufman make their home in the Sunset Hills of Pūpūkea. Upon entering the glass bamboo double doors one is quickly embraced by the cool spaciousness of their tropical Asian chalet. A panoramic view of the ocean, ideal for whale watching, rests before them, encouraging even the most harried person to pause and inhale its beauty.

And hanging majestically on the walls are Sarah's quilts that soften the heart and create a contrast to the use of cool, natural slate, concrete floors and counter tops they love. When the Kaufmans assisted in the design of their home, they did not realize how important her quilts would be to create a comfortable environment in such a solid foundation. Not only did it bring color and comfort into the room, but it also acted as a buffer for unexpected levels of sound.

Sarah originally owned a fabric store in the early '80s that specialized in high fashion fabrics and natural fibers. Her favorite colors are warm ones like mango and caramel, which can be found in many of her quilts. Her quilt studio is down stairs, a haven for her stash and a design wall that always has something wonderful in process.

Initially, Sarah saw natural fibers like the wool rugs and quilts as accents to the Indonesian and Bali furnishings they had chosen. But she was amazed to find how it also softened her floors and walls and even the sturdy dining table made of old Bali timbers. Speaking of timbers, while they were building, the Kaufmans got word that fallen monkey pod trees were rescued from Queen Emma's Summer Palace, and available for purchase. They bought them and had them delivered to Pūpūkea where they were milled right there on the property to make doors, pillars, cabinets and trims.

There is a sweetness of *aloha* at the Kaufman home...you can tell, even the plants are happy.

----- ✳ -----

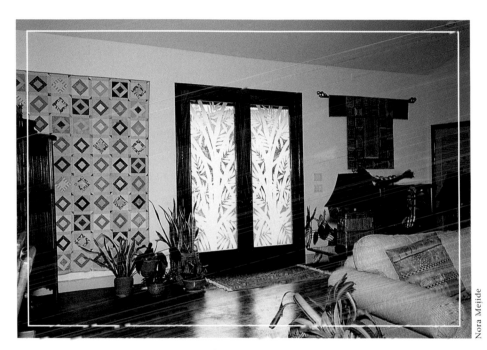

Nora Mejide

THE KAUFMAN HOME
Quilts and decor by Sarah Kaufman.

NAUPAKA

Margo Morgan's quilting experience began in the early '40s, the day her friend Maggie said, "Eh, you *hapai* now, it's going be one girl, you better start quilting." Margo lived in Ka'a'awa, so they went to Kaya's Store in Punalu'u, which used to sell fabric...now it sells fast food, camping gear, rakes, feed and fishing supplies. They bought enough fabric to do a bed-size quilt, and with the few colors that were available, they chose 9 yards of red and 9 yards of white.

On their way home they stopped in Kahana at the home of Aunty Sarah Kekuaokalani. She had patterns, and when Maggie introduced Margo, the soon-to-be-quilter, Aunty said, "The patterns over there, under the bed, help yourself...get plenty." They came away with two or three and Margo was excited. Red Ginger was the chosen pattern. Maggie helped her to lay it, cut it out, and the rest is history.

We quilters usually start with a pillow cover...but not Margo. As years went by, she was busy raising a family, but still found some time for quilting. She would appliqué quilt tops and took her appliqué with her to the North Shore, sitting under the ironwood trees, stitching and watching her boys while they surfed. She says that her quilting became more productive once their family bought a TV. She could quilt and listen to TV, and is still quilting today.

This quilt is entitled *"Naupaka"*; a quilt design she acquired from the Kawaiaha'o Church Quilters group. Finished in 1977, this is one of her favorite quilts because she really feels the designer captured the essence of the tiny *naupaka* blossom, a legendary flower that blooms not only by the sea, but in the mountains as well. *Naupaka* is one of her quilts featured in the 2003 Kokusai Art Show in Japan. When asked how long it usually takes her to complete a quilt, because she is known for doing the big quilts, she says, "about two years. It's a nice, relaxing thing for me to do. It's very difficult for me to sit and do nothing. I just quilt them and put them away, and when the spirit moves me, I happily give it away."

----- �֎ -----

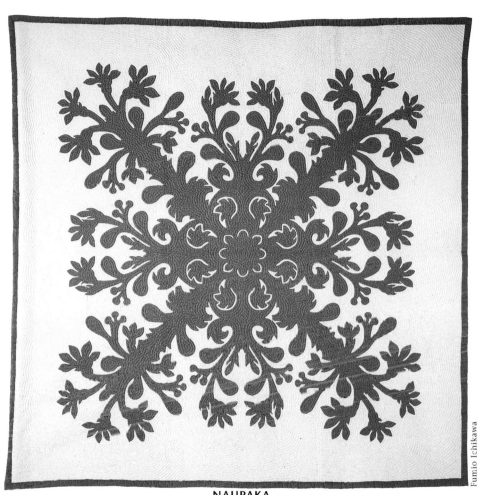

NAUPAKA
Hand-quilted by Margo Morgan, 1977.

LOGAN'S TURTLE QUILT

When Lincoln Okita and his wife, Jo, moved to South Dakota after their graduation from college, they were headed off to work at an Indian reservation hospital and found themselves with lots of free time. "Not very good television reception," Lincoln said.

One day while visiting a Native Indian Craft Fair, they spotted a Lone Star Quilt and purchased it. Upon examining it closely, they both agreed that it was something even they could do. So, off to the big city they went to get supplies, and together, made their first quilt, which they still have today.

That was the beginning of the Okita quilting legacy. Not only did it keep them occupied, but warm as well. Before returning home to Hawai'i, Lincoln experimented with a Hawaiian pillow appliqué pattern which he found in a book, and vowed that he would never do again. But life would offer him new opportunities to revisit Hawaiian quilting, and over the years, and several quilt projects later, Lincoln is noted as one of Hawai'i's finest hand quilters. Jo is happiest at the machine.

Featured here is "Logan's Turtle Quilt." It is just one of his quilts chosen to be featured at the 2003 Kokusai Art Show in Japan. Logan is their daughter, who is now in college. He knew he wanted to do a special quilt for her; perhaps a sea turtle theme, which she loved. He searched for the "just right" turtle fabrics, the watery background, and then the coral reef fabric. He found everything he needed on a hula trip to the mainland with the family. On the plane ride home, he drew out the quilt on a napkin which he still has today.

Lincoln speaks very fondly of this quilt, feeling driven to work on it. His fingers just flowed with the needle, the same needle he used for the entire quilt. The appliquéing, of the tiny coral fingers was his greatest but most satisfying challenge.

This was not just an ordinary design, it was a study in evolution of the various growth stages of the turtles, from hatching, to the safety of the coral reefs and beyond. It was also Daddy's metaphor for the love and awareness of the coming of age of his daughter, Logan.

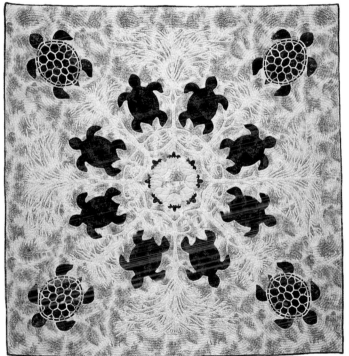

LOGAN'S TURTLE QUILT
Designed and hand-quilted by Lincoln Okita, 2000.

ALLEN AKINA'S 'ULU

Allen Akina the late famed Hawaiian artist, was a precious inspiration to me. We were friends who worked together in a tiny shop in Chinatown in the '70s. He was the consummate fashion designer of the time, using his hand silk-screened textiles to elegantly dress women of Hawai'i. Women from every island came to Allen when it was time to consider a fabulous look for a gala Hawaiian event like a *Holokū* Ball, an evening at the theater or a grand *ohana* wedding.

To this day, I always feel most beautiful when I'm wearing one of his gowns designed especially for me. Collars are high, sleeves are muttoned—usually sheer, lines are long, skirts full and flowing...all I need is a fresh *wili* lei, and a graceful fan.

One of his most recognized textile designs that I inherited was the *'ulu* design. It is a very meaningful symbol to me, one that I use as my logo. *Ulu* represents abundance, prosperity, and increase. I have made several quilts using this particular printed design. They have been used most often on *pūne'e,* or day beds, in island homes. These are not handmade quilts, but machine stitched for easy wear.

This *'ulu* quilt is simply taking his fabric and hand quilting around the printed design. It was simple, peaceful work; a way to honor his art and keep it close to me...something to remember him by.

----- �֎ -----

"Happiness lies in the joy of achievement and the thrill of creative effort."

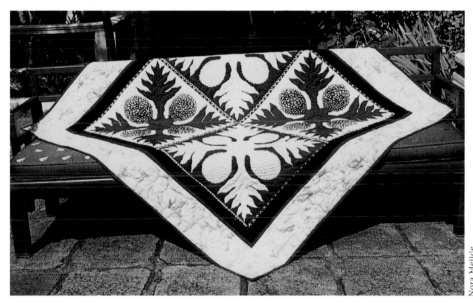

ALLEN AKINA'S ULU
Textile design by Allen Akina. Hand-quilted by Patricia Lei Murray, 1997.

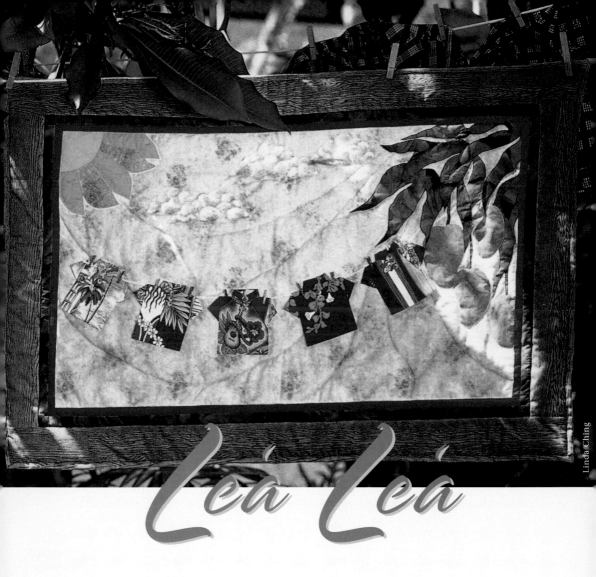

Linda Ching

Leʻa Leʻa

Fun

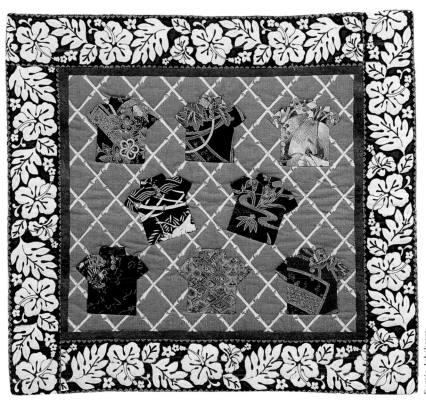

Fumio Ichikawa

CELEBRATING ALOHA
Designed and hand-quilted by Patricia Lei Murray, 2000.

This little quilt, entitled "Celebrating *Aloha*," was made in honor of the Year of the *Aloha* Shirt, 2000. I chose these Oriental fabrics because the first *aloha* shirts were made from Japanese *yukata*, or summer kimono, fabrics. In the '30s they were being sold in Chinatown and considered a slow mover. So, one day, the owner put the shirts in the shop window and they sold like *manapua*, hot Chinese Dumplings! The *aloha* Shirt business has never been the same...it's a world wide industry making a sweeping Hawaiian statement.

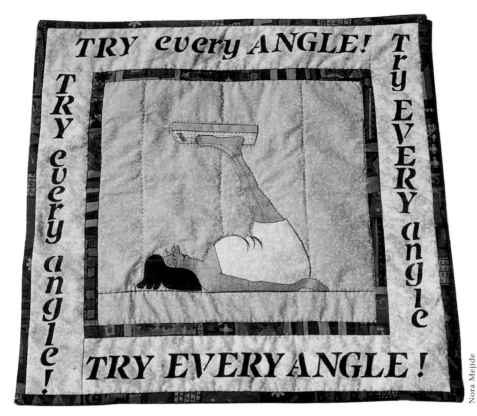

Nora Mejide

TRY EVERY ANGLE
Cartoon design by Annie Tempest. Hand-quilted by Patricia Lei Murray, 2003.

"There is no genius without a touch of madness." —Seneca

*"To love what you do and feel that it matters,
how could anything be more fun?"*

TRY EVERY ANGLE!

The Hawaii Quilt Guild 2003 Quilt Show's theme was "Try Every Angle." As guild members we were encouraged to use our imaginations and come up with something expressing this theme. Did I have a good time with that! I interpreted the theme as Try Every Angle!

I found this cartoon in a magazine and just had to duplicate it as a quilt. As quilt sisters, we're all constantly fretting about our weight, and trying every angle to lose. My sisters and I laugh and agree it's the story of our lives. My compliments to cartoonist/writer, Annie Tempest, whose cartoon we have all enjoyed. Maybe I should make one of these for her, and send it to England where she lives.

----- �֎ -----

"A good laugh is sunshine in a house."
—William Makepeace Thackery

"Some men dream of worthy accomplishments,
while others stay awake and do them."

My husband, Harry, was celebrating his sixtieth birthday. All the arrangements were made for a lovely dinner party at the Princess Ka'iulani Hotel. Our children came home from all over to perform for their dad. Family, friends and couples we grew up with were there to help him celebrate, and feel the *aloha*.

At each place setting our guests received a cheerful, *origami aloha* shirt made of island wrapping paper. My friend, Wayne Harada, taught me how to fold the shirts, so our family folded dozens and used them as favors. Everyone loved the shirts. They were a hit!

A few weeks later, while working in my studio, I folded the shirts out of fabric, and a whole new quilt idea came to life. I called Wayne asking his permission to adapt the idea, and happily he gave me his blessing. So, one of the very first quilts I made went to him...Aloha Shirts Hanging on a Clothesline. Wash day at my childhood home in Kalihi was exactly that, *aloha* shirts hanging under the mango trees. It was fun to recreate that image, and to visualize my sisters and I climbing the trees and eating the *mele* mangoes right off the tree.

Mr. Toshiyuki Higuchi, of Kokusai Art in Japan, saw a photograph of Wayne's quilt in *the Contemporary Hawaiian Quilts book*, and fell in love with it. Soon after, I received an invitation, along with five other artists, to show quilts in a quilt show sponsored by Kokusai Art Show in Japan. I think it's the *aloha* shirts that got me into the show. And since I no longer had the quilt, I needed to make another one...this time with more mangoes.

----- �֎ -----

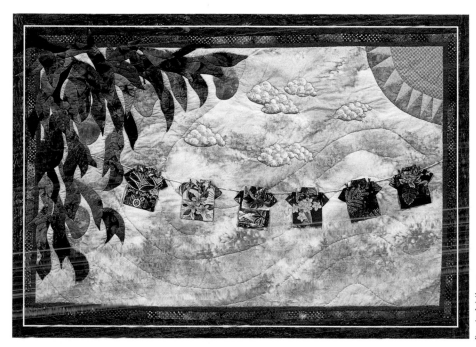

ONE CAN NEVER HAVE TOO MUCH ALOHA
Designed and hand-quilted by Patricia Lei Murray, 2003.
For Mr. Toshiyuki Higuchi.

Perhaps the most significant way to perpetuate any of the cultural arts is to share it with the young. We can always give our children quilts, bringing them comfort for a season, but better yet, by teaching and inspiring our children to quilt, we perpetuate a culture!

Here's just one of the ways we can accomplish this. Invite them to share their art work with you, and show them what you can do with it. Once they see their work framed in fabric and up for the world to see, they'll want to do it for themselves.

I had the pleasure of doing this with my granddaughter, Crystal, when she lived with us for a while. She reproduced a self portrait she had made earlier and together we made it into a quilt. Here's what we did.

Our first step was to take a piece of muslin and iron freezer paper on the back of the cloth. It made the cloth stiff, like a piece of paper, and gave her greater control of the fabric as she used large crayons to draw her picture. When she was satisfied with her drawing, I sealed the crayon drawing to the muslin by placing a piece of fabric over it and ironing the top cloth.

Together we picked out the fabric for the borders, measured the sides, cut what we needed and framed the art. Once the quilt top was made, we created a sandwich of backing, batting and top. She watched me as I stipple quilted the piece, and she saw it come to life.

A few months later we tried a new process, still framing her art work. She made four little pictures that I bordered and prepared for quilting. Then I taught her to use needle and thread to simply quilt around the image. We worked on it a little at a time, and strived for even stitches. It was difficult at the beginning, but with small sessions, we were able to finish. And it was so much fun for the both of us to hear her say...*Puna, I did it!*

----- �֎ -----

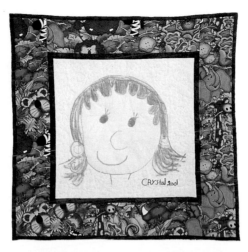

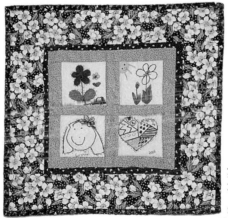

Nora Mejide

CRYSTAL QUILTS
Art work by Crystal Murray. Quilted by Crystal and Patricia Lei Murray, 2002.

"Every noble work is at first impossible." - *Thomas Carlyle, 1978*

"Great things come from small beginnings."

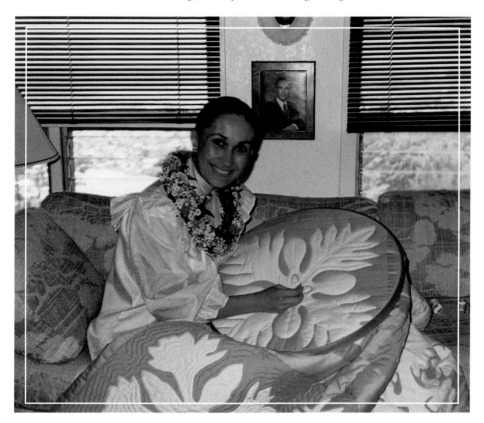

Although I started quilting later in life, I began with small projects like this one, one block at a time. Each finished block represented stepping stones of progress, encouragement and confidence. Stitches improved, shoulders and fingers relaxed; all through practice and desire. And the outcome...something wonderful at the end of a great effort.

Pu Ana Ia Me Ke Aloha
I sing the refrain with love.

What words of *aloha* shall I leave with you, like those at the end of a sweet Hawaiian song? Perhaps this *mele,* or poem, can give you something to hold onto.

The Kapa

I leave you my *Kapa.*
She will speak for me.
Within the rows of careful stitches,
I leave a message, echoing my thoughts.

Choose Color
Select and Follow a Pattern
Develop Skill
Keep a Steady Course
Sense a Rhythm
Slow Down
Embrace Daily
Work Daily
Breathe, Relax
Love, Live
Give.

Patricia Lei Murray 2003

77

- BIBLIOGRAPHY -

Arthur, Linda. *At the Cutting Edge, Contemporary Quilting.* Honolulu: Island Heritage Publishing, 2002.

Brandon, Reiko Mochinaga and Loretta G. H. Woodard, *Hawaiian Quilts, Tradition and Transition.* Tokyo: Kokusai Art, 2003.

Brandon, Reiko Mochinaga, et al. *The Hawaiian Quilt.* Tokyo: Kokusai Art, 1989.

Hackler, Rhoda E.A. and Loretta G.H. Woodard, *The Queen's Quilt.* Honolulu: The Friends of 'Iolani Palace, in press.

Horton, Karen. "Quilting Hawaiian Style", Spirit of Aloha. Honolulu, 1983.

Lili'uokalani, Queen. *The Queen's Song Book,* Honolulu, Hui Hanai, 1999.

HAWAIIAN ANGEL
By No'eau Penner, 1999.

A	
AKUA	God
ALOHA	Love, trust, compassion

E	
'EHA	Pain

H	
HAOLE	Caucasian, foreigner
HĀPAI	With child
HOLOKU	A long, formal dress
HO'OKUPU	Gift, offering
HO'OPAŪ	Close, finish
HUAPALA	Sweetheart, lover

K	
KA'A'AWA	A district on the Windward side
KA'IULANI	Princess, niece of Lili'uokalani
KAHANA	District on the North Shore
KAPA	Quilt
KAPA MOE	Traditional tapa bed coverings
KAULA	String, cord, thread
KAUNALOA	Endurance
KĪ	Ti leaf plant
KŌKUA	Assist, help
KUMU KUIKI	Quilt teacher
KUPUNA	Grandparent, ancestor

L	
LAU	Leaf
LAUA'E	Fragrant fern
LAU HALA	Pandanus leaf used in weaving
LE'ALE'A	Fun, joy, pleasure
LEI NAHELE	Woodland fern
LUANA	Contentment

M	
MAHALO	Gratitude
MANAPUA	Hot Chinese dumplings

MANAPUA	Hot Chinese dumplings
MĀNOA	District in Honolulu
MELIA	Plumeria

N ———————————

NAUPAKA	Legendary native shrub

O ———————————

'OHANA	Family
'ŌHI'A LEHUA	*Metrosideros collina*

P ———————————

PAOAKALANI	Waikiki home of Lili'uokalani
PĪKAKE	Fragrant, highly prized jasmine
PONO	Goodness, right, excellence
PUA 'ENA	Passion
PUNA	Short for Grandmother
PUNALU'U	District on the North Shore
PŪNE'E	Day bed
PŪ'OLO	Bundle
PŪPŪKEA	District on the North Shore

T ———————————

TAPA	Cloth made of beaten wauke

U ———————————

'UHANE	Spirit, soul
'ULU	Breadfruit
ULU	Abundance, increase, wisdom

W ———————————

WAI'ANAE	District in East O'ahu
WAIMEA	District on the Big Island
WAUKE	Paper mulberry bark
WILI	Wind, twist, in lei making

Phrases ———————————

E KIPA MAI
(Welcome)
KU'U HAE ALOHA
(My Beloved Flag)
UA MAU KE EA O KA 'ĀINA I KA PONO
(The life of the land is perpetuated in righteousness.)